CUT & COPY

proudly presents...

How To's

Have a Beary Happy Birthday

Creative Clip art ideas, projects and inspirations to get you going!

© Dianne J. Hook 1995

I couldn't wait to start this HOW-TO'S Cut & Copy book... but just between you and I, it should have been the very first book I put together. I'll tell you though, the more I saw incredible projects and met with friends who were learning to use the Cut & Copy books and using the copy machine as a craft tool, the more I was learning, and therefore kept thinking...I'll just HAVE to add that to the HOW-TO book...so before my list of a thousand ideas and projects gets any larger and I'm not able to compile it all, I WILL put this HOW-TO book together so you can see and create some great copy projects. I hope it helps you create some fun projects that don't take a whole lot of effort or creativity to make each one look 'ohhhh so cute!'

Like I said above, it's been great to see copying as a craft. I love going to a copy shop and visiting (in awe!) with the people making wonderful projects. Work charts for their kids and school, newsletters for the family and church, calendars that are personalized and geared just for your family or situation, simple little note pads with a message that's straight from you, and all of those sweet hand-outs for a million different uses. However, I am still surprised how some people still need the basics on copying. So, I want to go to the very Cut & Copy start and explain in detail a few basic ideas and what NOT to do and what TO do.

To begin, have a particular Cut & Copy project in mind. It may be an invite, flashcard, thank you note, tag, etc...next go to your Cut & Copy book that has the character, secondary characters, and fillers you think would best fit your project. It's important to have all the right components (that's what I like to call the clip art pieces...) to make your project turn out well. I've always seen art a little different than most people I know... I look at all the little pieces of a scene, not just the picture as a whole. I loved playing paper dolls as a little girl, I would draw the clothes, the doll, the little tea sets, and the wallpaper behind that I would use and combine them all together for hours of fun. Cut & Copy is essentially the same thing, but I've done the drawing for you. What *your* doing is combing each piece to make the project uniquely yours.

I'm often asked if you should cut the designs out of the Cut & Copy book...NO! Make a copy of the particular design you want, then your Cut & Copy book will last for years. A little tool called a 'proportion scale' which you can find at a art supply store is great for taking with you to the copy store. It will help you determine the size you need to reduce or enlarge the design to. Standard reductions and enlargements on the copy machines are 95%, 77%, 64% and 121%.

Second, cut out each design you will use, leaving just a tiny edge around. Now begin to combine your pieces by overlapping and combining your components on a clean piece of paper. Use removable tape (my favorite), or rubber cement, or removable glue stick so you can move the pieces around and use a design again from project to project. I like to keep an envelope glued in the back of my Cut & Copy book to put the cut out pieces in, so they stay nice. And I also don't have to make so many copies if I use the designs repeatedly.

Layout is important. Start with a Cut & Copy Border around the outside edges first. Whether your project is large or small, a 'frame' is important for a complete project. Second add the character you've chosen (like Rex) and then the secondary characters (the bone and the doghouse). Fillers, like the hearts, dots, etc., are added last. Remember to stay within a 1/4" of the edge of the paper so it will copy well every time. Try to combine your designs in uneven numbers, combinations of threes and fives always work well. The eye can travel around your page well with those numbers.

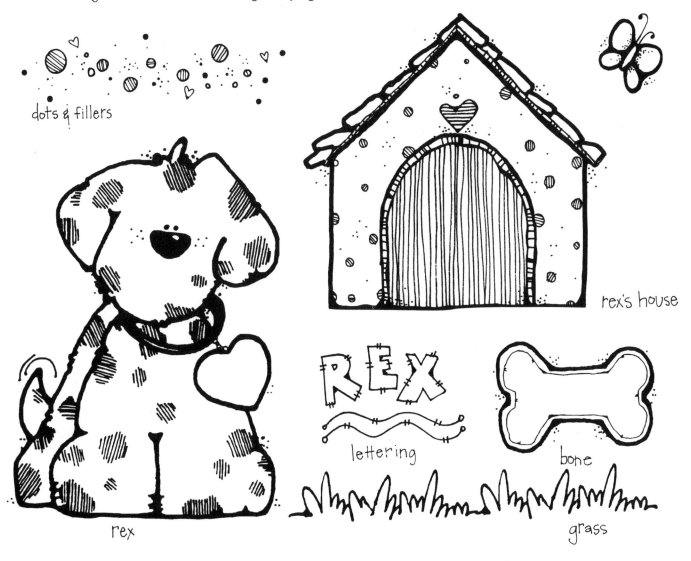

dots & fillers

rex's house

rex

REX

lettering

bone

grass

On this page you can see the combined pieces for our Rex stationery page. Look at the problems on the left side, and how to correct them on the right side. The list of things to take with you to the copy shop will help you through all of these steps...many times the copy shop doesn't have the right materials, or supplies, etc. to make your project look good, so always take your own copy tools in a zip lock bag to ensure that you can make the project turn out like a pro!

things to bring
to the copy store:
♥ Cut & Copy books
♭ proportion scale
♥ removable tape
♥ ruler

♥ fine-tip felt pen
♭ scissors
♥ white-out

This stationery page is complete, but remember you can use it for a bunch of ideas, like a memo pad, a newsletter, scrapbook page, or many others. Always save your Cut & Copy project ideas in an idea folder so you can use them again and again.

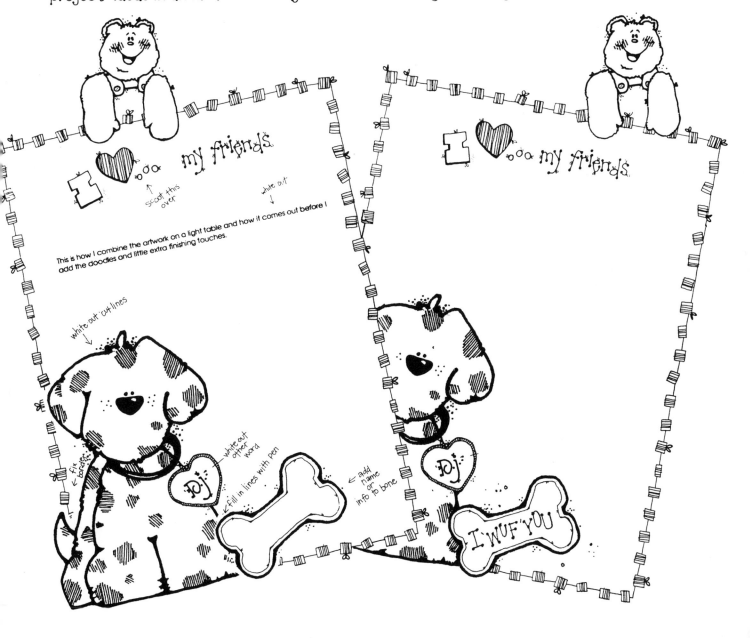

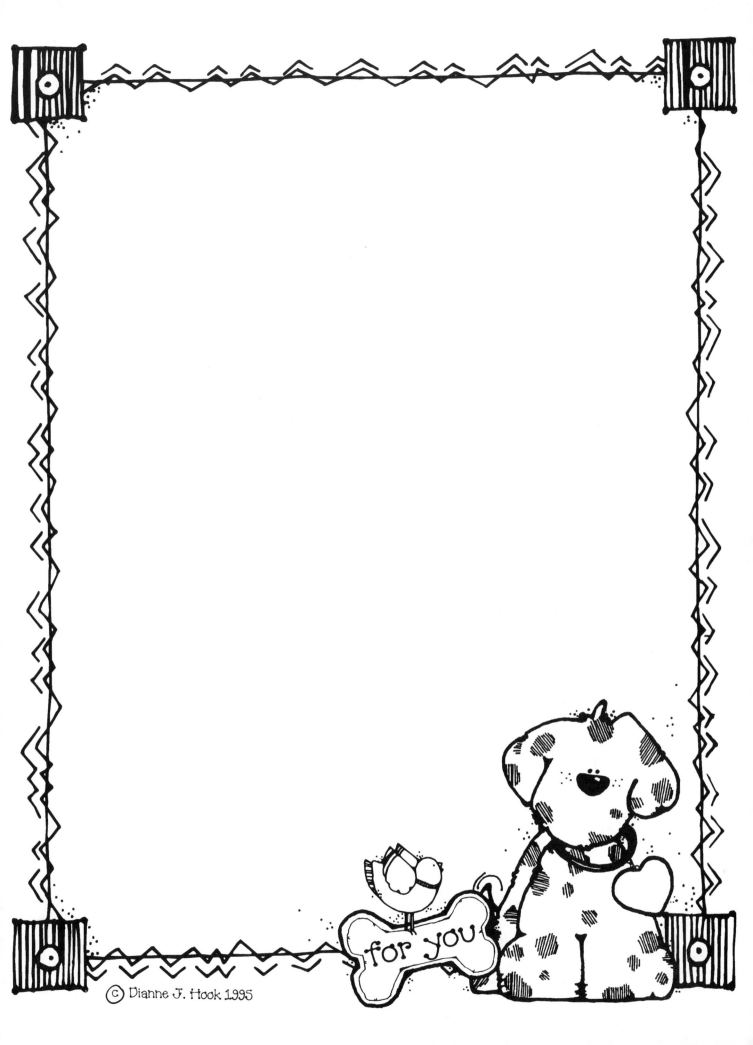

© Dianne J. Hook 1995

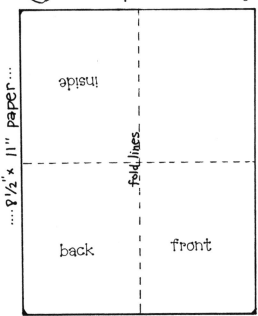

Now let's make a simple note card. Personalizing your cards and making them just from YOU is such a plus! Follow the basic Cut & Copy procedure, but as you start to work on your layout, fold your layout paper in half, then half again, make certain that you face your design in the correct position so that you can fold them up the right way.

...8½" x 11" paper...

fold lines

inside

back front

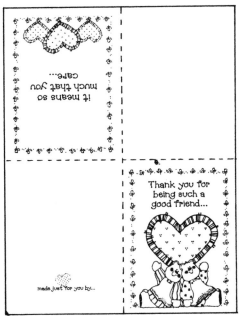

it means so
much that you
care...

Thank you for
being such a
good friend...

made just for you by...

Here is another version of a simple half page card. With this card you copy it ' two up' (meaning the exact same thing on both sides of the paper) and then copy the other side of the paper if you would like a message on the inside of your card. I love this type of card and generally copy five or ten and use them for all occasions. It's such a plus to make a cute envelope (on the following page) that coordinates with the card... My kids love to make these Cut & Copy cards by the dozens, and I encourage them to send and write cards and letters often, so it's perfect to have them create cards the way they like them to be as well.

cut line

SIMPLE FOLD
CARDS

This envelope is designed to fit the cards on the previous page. Add the character or the secondary character to the front of the envelope and have it all coordinate. Make a set of twelve cards and envelopes (personalizing them for a real special gift or occasion!) and wrap it up with a little ribbon. You're gift will be a HIT!

ENVELOPE

Here are some layout ideas for long tags, bookmarks or whatever else comes to mind. This rectangle shape is designed to copy 'four up'. I use to try to measure my layout paper with a ruler and pencil to figure out my lines accurately, til a friend showed me that *folding* the paper first before I did the layout of the designs made my lines more accurate and easier to re-do if I goofed.

I love to create a page of Cut & Copy bookmarks, laminate them and punch a whole in the bottom of each and add a ribbon tassel to give as a gift with a book, for my friends. Bookmarks tend to last and are more usable than cards. Remember to sign the back of the bookmark with a sweet message before you laminate.

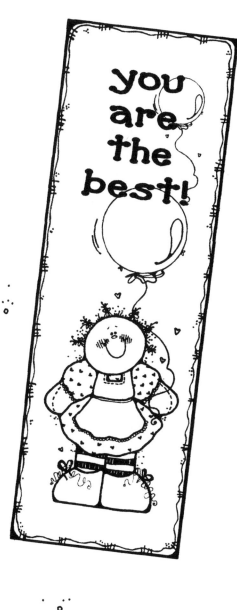

LONG TAGS and BOOKMARKS

Ahhh..the joys of scrapbooking. I can't say enough good about creating scrapbooks as a hobby and lasting piece of art for your family and loved ones. I have really enjoyed the last year, traveling all over the United States, seeing the different memorable pages people are creating with the Cut & Copy clip art. You could spend hours creating and making each page individual and unique. I hope I can give you a few ideas that will get you started, or want to anyway!

♥　　　Organize your pictures into 'years'...this makes the memory process much easier.
♥　　　For heaven's sake get your pictures out of those yucky old magnetic photo albums. They are the very worst thing for a photograph or any paper keepsake. In fact the worst things for photos are: magnetic photo albums, sunlight, water and high humidity in the air, oil on hands, and extremely high acid content.

Supplies to have on hand when you create your pages...

♥　　　Non-acid glue (like Dennison's glue stick, corner mounts, ZIG two-way glue, or mounting tape) again, make sure that this is an acid free product since it will be going next to the picture.
♥　　　Acid-free paper...it is now available at so many paper supply stores in ALL kinds of colors and textures.
♥　　　Pigment pens...to ensure the color won't fade or smear over the years. Most pigment pens are waterproof and therefore won't leave watermarks either.
♥　　　Acid-free sheet protectors.
♥　　　Good three-ring binders (they also come in SO many great colors and fabrics!)
♥　　　Stamps, stickers, paper punches, decorative scissors, and stencils are just a few of the great 'toys' to play with to make your pages come alive! Start a collection of these things and you'll never regret it!

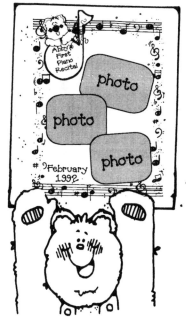

Cut & Copy books are PERFECT to start your scrapbooks. They give you a picture base to work with. Copy a bunch of pages (especially from the BORDERS book). Copy the main character from the Cut & Copy book, then stamp the embellishments around the design. Or just the opposite idea...copy the border and simple designs and then stamp the main character and add to the page.

SCRAPBOOKING

While you are stamping, for scrapbook pages, Color Box stamp pads are recommended. If you prefer using the water based stamp pads, make sure that you put your pages in sheet protectors to save them from smearing or being watermarked. Embossing stamped images is the best idea for longevity.

Crop your pictures creatively so you can get more than two or three on a page.

Always get duplicates of pictures. It's worth the extra cost to send some to Grandma and have some to do your pages creatively.

Share your great pages with others by color-copying them. Color-copying is an acid-free process and will last for many years also. Give friends a scrapbook page instead of a card...they'll enjoy it for years to come!

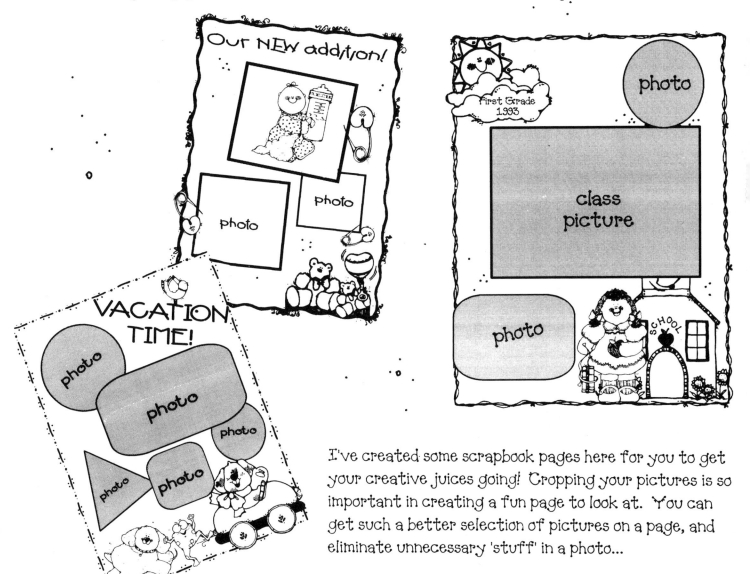

I've created some scrapbook pages here for you to get your creative juices going! Cropping your pictures is so important in creating a fun page to look at. You can get such a better selection of pictures on a page, and eliminate unnecessary 'stuff' in a photo...

This is a 'border'... simple and easy. I have a whole book of Borders by the same name published by Carson Dellosa Publishing, as well as having the same designs on software (Cut & Copy for Computer BORDERS) I just LOVED drawing. I had the scrapbooker utmost in mind as I created this book. Without too much work, you can copy the Border page, right out of the book onto acid-free cardstock and place your photos and mementos, and TA-DA your page is complete! Of course you can add the other characters and fillers as you see fit but this...is a Border. On the next couple of pages you will find borders to use with the clip art from the Cut & Copy books. Start with these simple borders for your first Cut & Copy projects...

love for Time and Eternity

BORDERS

© Dianne J. Hook 1995

Now let's add some background patternfillers...I just started to draw them in the last few Cut & Copy books, and I LOVE what I am seeing done with them. They are super to copy and use 'as is' for a scrapbook page, flyer, stationery, etc. A great idea I recently saw was the envelope on the previous page (?) traced onto a background pattern, cut out and assembled then they used the same background pattern copied straight out of the book as the stationery inside. It was darling! Look at a few of the ideas I have on this page for the background patterns with Cut & Copy designs and then try a few with the background patterns I've included in this book. Can I just add here... I have a great new line of papers called *PaperDoodies* which use the same concept with background pattern designs in wonderful colors and designs...look for them at your local craft stores.

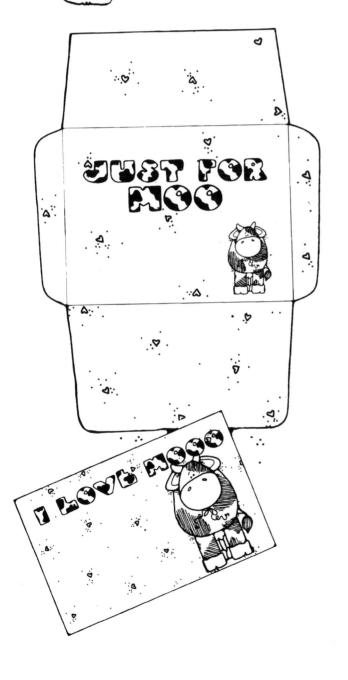

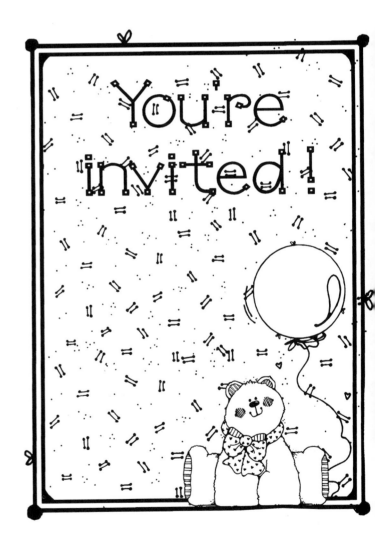

BACKGROUND FILLERS

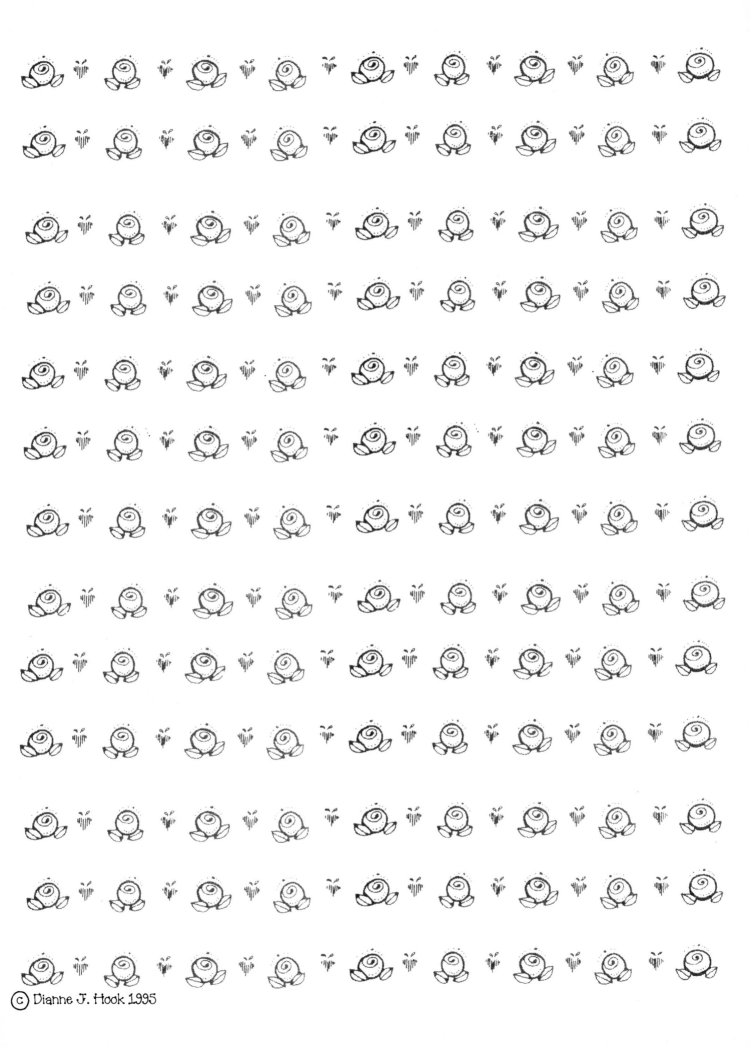

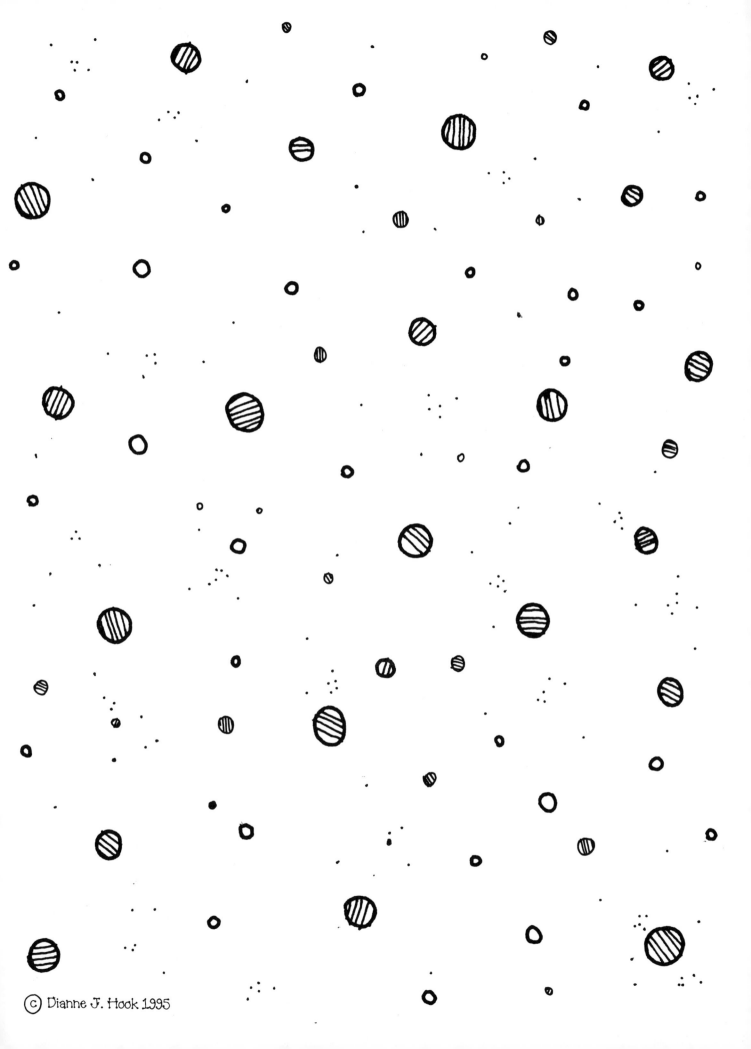

The joy of frames! I love them...even on paper. They are a perfect Cut & Copy project. I've seen so many cute baby books made with this basic frame idea. Again, you can laminate this frame project after you have added the appropriate designs, copied, cut them out, colored and decorated as you see fit, add a back to the frame, the same size as the front and a ribbon ontop for hanging. What a super gift for a child to give a grandparent with their current school picture! I know my Mom would love it. Below are a few ideas from me...and the Cut & Copy book I got the frame and designs from...then on the following page are a couple of frames for YOU to try!

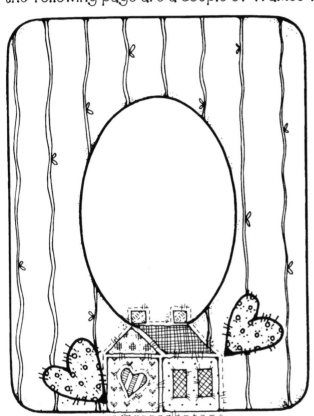

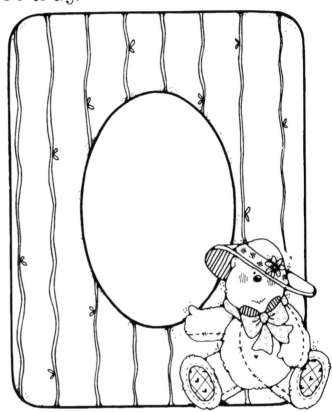

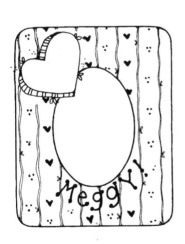

FRAMES

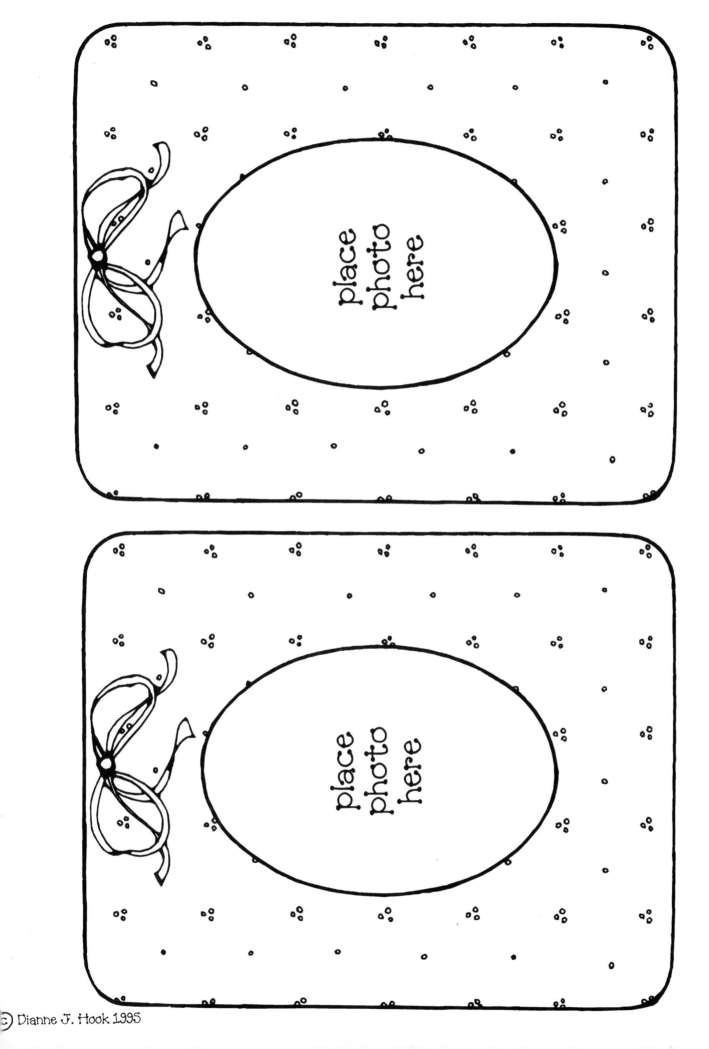

place
photo
here

place
photo
here

I am always searching for great new projects for my kids....as I am blessed with five children, believe me, it is a lot of searching! They all love arts and crafts and are required by law (or Mom) to LOVE Cut & Copy books and projects. They constantly help me think of new things to do with the designs. Because I copy an extraordinary amount, they always have plenty of designs and supplies to get them started. Here are a few of their favorite projects, and mine...and NO the Cut & Copy books are not coloring books! That statement makes me CRINGE! Make *your own* personalized coloring book from a Cut & Copy book, but don't use the real thing.

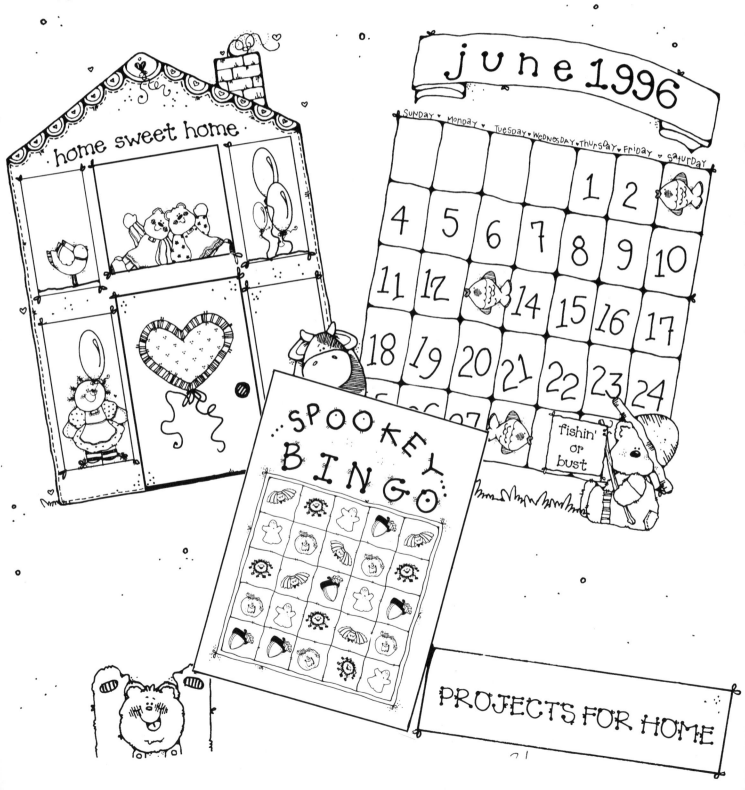

home sweet home

june 1996

SUNDAY	MONDAY	TUESDAY	WEDNESDAY	THURSDAY	FRIDAY	SATURDAY
				1	2	
4	5	6	7	8	9	10
11	12		14	15	16	17
18	19	20	21	22	23	24

fishin' or bust

SPOOKEY BINGO

PROJECTS FOR HOME

Here is a good ol' BINGO game that you can add the different designs and characters to to create a game that works for the occasion. My kids love doing theme parties with this BINGO chart and making up funny names to call out the letters and numbers...try it for the next party where you're in charge of the game! Laminate the game boards afterward so you can use them time after time.

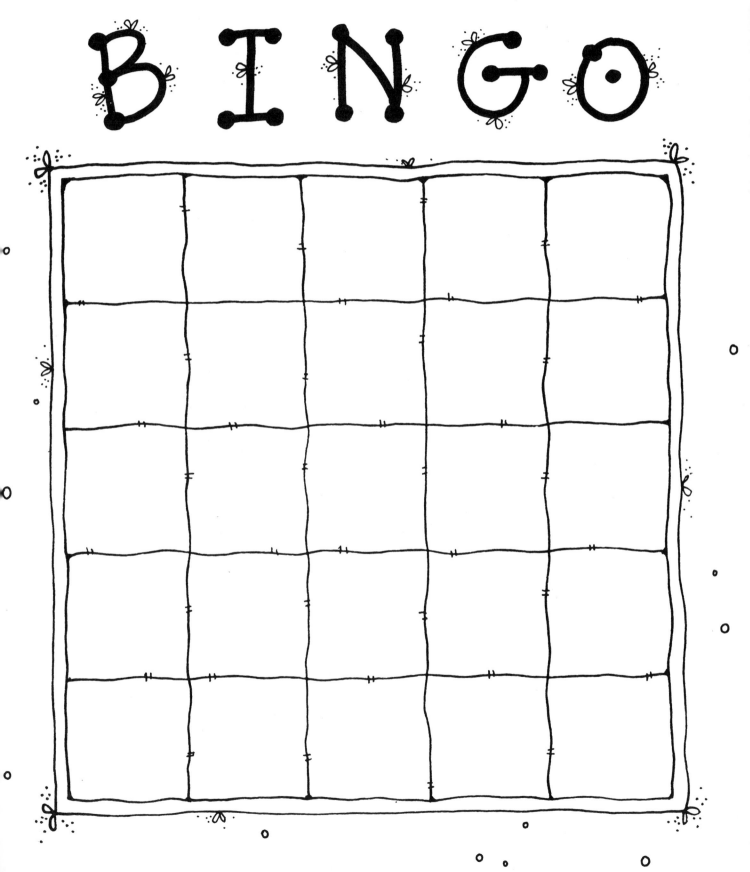

This is a very generic work chart that I use for my kids...I fill out their name on the top, then list the chores they need to work on through the week on the left, and as they complete the chore I let them check it off by stamping the square with their favorite stamp. Work this chart the way that you see fit for your family too!

SUNDAY ♥ MONDAY ♥ TUESDAY ♥ WEDNESDAY ♥ THURSDAY ♥ Friday ♥ Saturday

CALENDAR

Fill this cute little house up with your own drawings, or copy your favorite Cut & Copy characters to play and move around the rooms and windows. Add all the fun little stuff (it's always great to cut things out of old magazines to add as fun pieces too. This goes back to the ol' paper doll days! My kids could just play with this chart and movable characters of their choosing for hours and never get bored. You'll be surprised how entertaining this is!

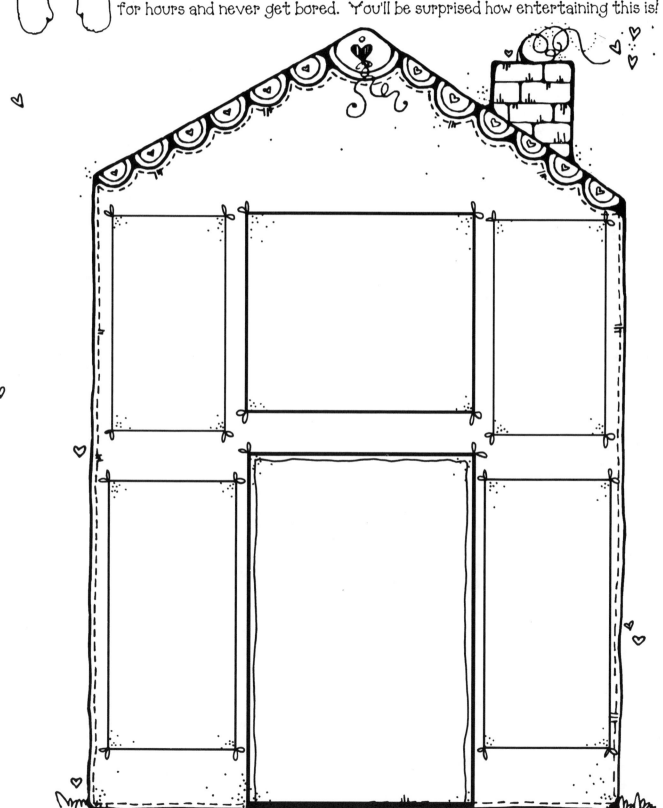

These tags you can use for a million different things..design each one the way you think best! Have fun with these, and use them in a million different ways! I also like to copy these onto plain cardstock and stamp them. I have several other tag designs in the D.J. Inkers Stamp Starters book.

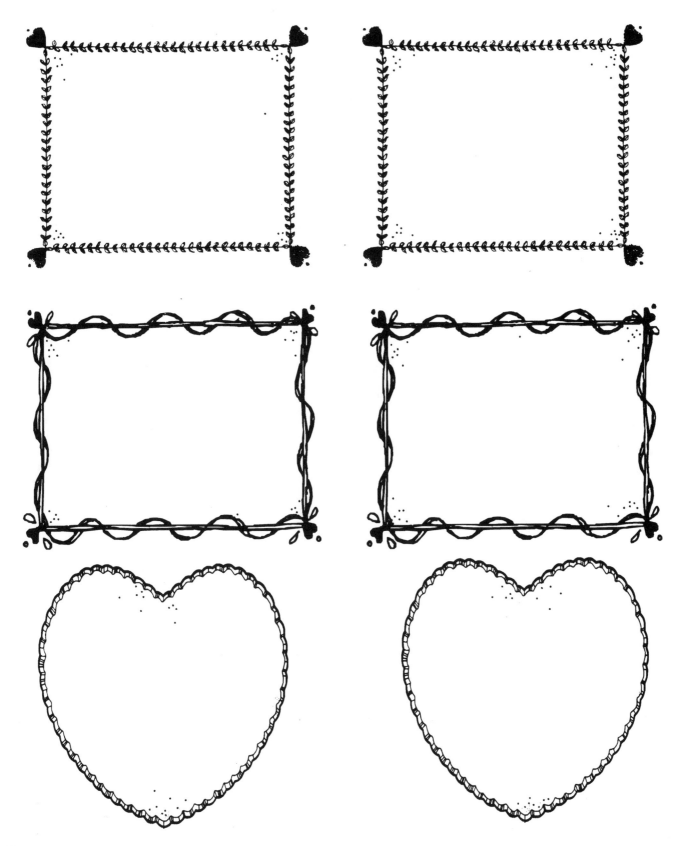

My oldest daughter is really into writing notes to her friends and loves to make Cut & Copy fold-it notes and little stickers that go on the back to seal it closed. They are great gifts as well, when personalized and copied on coordinating colored cardstock and wrapped up all sweet! Here's my ideas...you'll have fun creating this type of note for all occasions throughout the year.

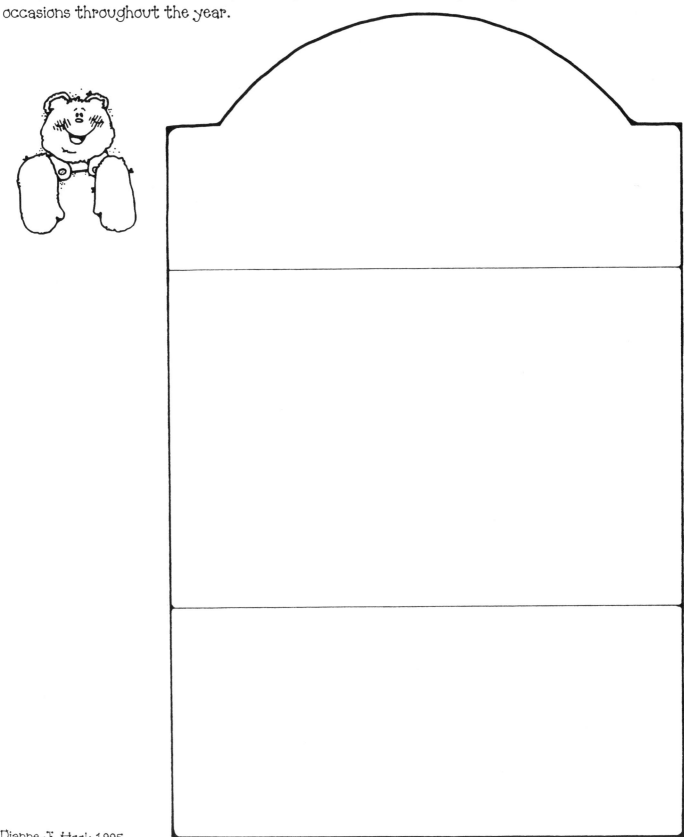

I wish I could tell you how often I've been asked to do a lettering guide...and how often I laugh at the idea! I had a third grade teacher that told me I had the worst hand-writing in the class, and would I PLEASE stop making my letters so silly! So to think people would want me to help them with lettering makes me smile. I have always had a love-affair with letters. The most incredible thing in the world was when I was able to develop the Fontastics! Computer package and type on a computer the letters that I had designed by hand. It's the best! Your hand-writing makes the project uniquely yours and special..so I've done some alphabets on the following pages that you can copy with the help of a light table or adapt to your own handwriting and do the same 'fancying up' that I have done to get the same effect for a variety of styles on ALL your Cut & Copy projects. The style below is great for celebrations of all sorts, birthday party invites, notes to friends, kitchen tags, etc.... Remember that I have the Cut & Copy for Computer FONTASTICS! program that makes it incredibly easy to just type this way if you just want to use your computer for all your printing!

A a B b C c D d E e
F f G g H h I i J j
K k L l M m N n O o
P p Q q R r S s T t
U u V v W w X x
Y y Z z

This is a sillly 'western' lettering style that I like a lot for so many projects. I love the outdoors and old wood signs and anything with a cowboy in it...so this letter style is one of my favorites. The wooden sign in the Cut & Copy All for Fall book is great with this lettering. Again, in the Fontastics! software package, this style is called 'DJ Signpost'...

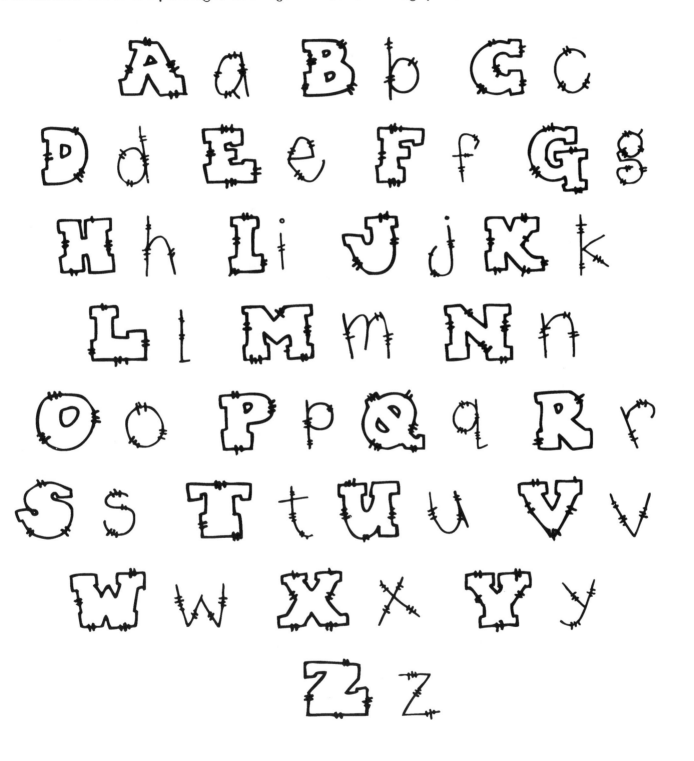

This style is for your fancy letters and notes and 'headlining' all of your nicer Cut & Copy projects...I call this lettering 'fancy'...again, use a light table or hold your paper up to the light to copy the letters, or just get an idea from the style I've created here and do your own thing.

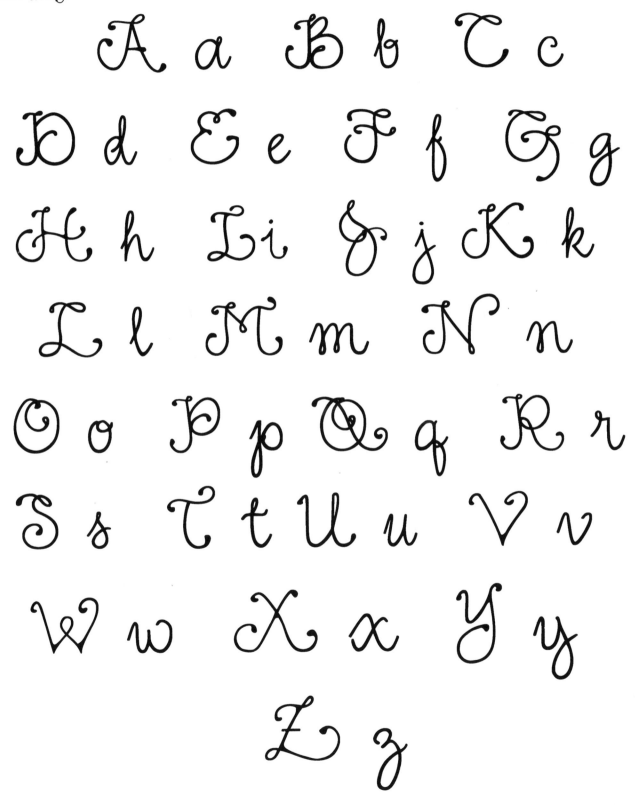

I hope a few of these 'inspirations' will help you to get started with your Cut & Copy clip art projects. Take a look through all of your Cut & Copy books, software, and stickers for more inspirations and projects that will make you smile! Here are a few fun pieces of clip art to get you going...

Take Care!
Dianne J!

what an angel you are!♡

We'd love to hear your comments, ideas and suggestions with our products. Please feel free to write us at...D.J. Inkers Post Office Box 2462 / Sandy, UT 84091